BREWING IN KENT

JOHNNY HOMER

AMBERLEY

This book is dedicated to Harriet and Lydia. They are my stars.

First published 2016

Amberley Publishing
The Hill, Stroud
Gloucestershire, GL5 4EP

www.amberley-books.com

Copyright © Johnny Homer, 2016
Maps contain Ornance Survey data.
Crown Copyright and database right, 2016

The right of Johnny Homer to be identified as
the Author of this work has been asserted in
accordance with the Copyrights, Designs and
Patents Act 1988.

ISBN 978 1 4456 5743 1 (print)
ISBN 978 1 4456 5744 8 (ebook)

British Library Cataloguing in Publication Data.
A catalogue record for this book is available from
the British Library.

Typesetting by Amberley Publishing.
Printed in the UK.

Contents

Introduction

Charles Dickens knew and loved Kent. He liked beer too.

The great writer travelled extensively around the county, and Kent features in many of his works, including *The Pickwick Papers*, published in 1837. There is one memorable moment in the book when Mr Jingle remarks: 'Kent, sir, everybody knows Kent – apples, cherries, hops and women.'

Many things have changed in the Garden of England since Dickens strode its country lanes and cobbled streets, but many things have stayed the same. Kent still has apples and cherries aplenty, and Kent still has women. And, despite some dark days over the years, Kent still has hops. Where there are hops, there are usually breweries, and where there are breweries, there is, of course, beer. It was ever thus in Kent, and long may it continue.

The story of brewing in Kent is typical of the story of brewing throughout Britain, with one notable exception: it was in Kent where hops were first cultivated for mainstream brewing use on these islands, most probably at Westbere near Canterbury in the early sixteenth century (a date of 1520 is often given), although there is some disagreement among historians as to where exactly in the county hops were first grown. Writing in the 1948 book *Whitbread Craftsmen,* Richard Church wrote of hops 'grown round about Maidstone district, where they were first cultivated'. Some, meanwhile, claim Little Chart near Ashford as the location of the first hop gardens.

Either way, what is certain is that hops were first grown in Kent specifically for brewing purposes and this alone ensures that the county can claim a unique place in British brewing history. Where, all things considered, would we be without hops?

Kent has since been closely associated with producing a plant that was initially treated with suspicion by many, branded a 'wicked and pernicious weed' by some. Indeed, some sources suggest that for periods in English history the use of hops was positively discouraged by authorities and was, perhaps, even illegal.

However, *Humulus lupulus*, to give the hop its Latin name, would go on to change the whole nature of British drinking, transforming un-hopped ale made from water, malted barley, yeast and a variety of flavourings, into the hopped beer we love today.

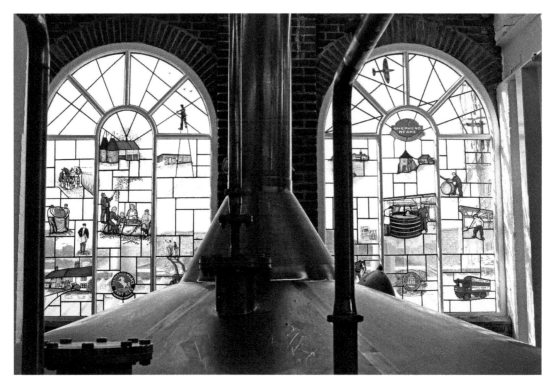

Stained glass windows in the Millennium Brewhouse at Shepherd Neame.
(Shepherd Neame)

Then, as now, Kent's relatively mild climate, brick earth and gentle winds, often tinged with coastal sea salt, provided the ideal environment for growing hops and, over the years, this much-loved herbaceous perennial has played a huge part in the economy of the Garden of England.

Certainly by 1530 both home-grown hops and those imported from the Continent were being used by English brewers and, according to Richard Filmer in *Hops and Hop Picking,* by 1655 there were fourteen English counties in which hops were cultivated. At the time a third of all English hops, adds Filmer, were grown in Kent. It was still thriving as an industry in Kent in the post-war decades of the 1940s and 1950s.

Hopping down in Kent

At the industry's peak in around 1870, some 77,000 acres of land were devoted to growing hops in Kent. And, as a vitally important element of producing quality hops was picking them at speed within a very narrow window of opportunity, a vast casual workforce was needed each September.

Kent locals and members of the travelling community all took part in the annual harvest, but the majority of the workforce were Londoners, often working-class family groups and predominantly from the East End, but also from other districts of the capital. Some estimates reckon that as many as 200,000 would make the journey from the smog of London to the clean country air of Kent each year, while 'Hopping

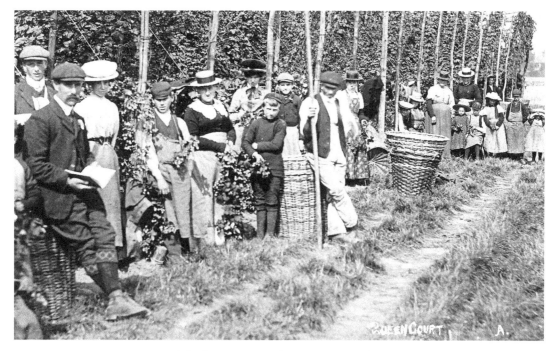

Hoppers in Kent, around the late nineteenth century, and (below) hops enter the copper.

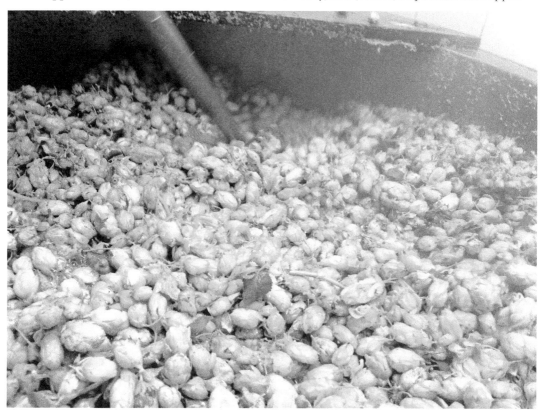

down in Kent' had a culture all of its own and became an annual working holiday for generations of London families, who would work hard by day and often unwind in some style afterwards.

Gilda O'Neill, in her wonderfully evocative book *Lost Voices*, spoke to many Londoners for whom hopping was an important annual event. One hopper told O'Neill that the local pubs were always 'full at weekends', although not all landlords welcomed Londoners with open arms. Some pubs would dedicate a separate bar to these loud and colourful customers from the capital, usually the more basic public bar, often charging a shilling deposit for the use of a glass from which to drink. Some pubs banned hoppers altogether and the 'No Hoppers' sign was a common sight on public house doors during the hopping season.

It was the after-work activities of many hoppers that attracted the attention of organisations such as the Church of England Temperance Society Mission, whose mission to help change the 'squalid conditions' in which many hoppers lived and worked only thinly veiled their temperance message. Today's neo-prohibitionists have much in common with these people.

Conditions for hoppers varied immensely from farm to farm. Some did have to put up with less-than-ideal conditions, but many were well looked after by their employers and, in such cases, a loyal bond between the two was often forged. There are records of generations of the same family returning again and again to work for the same farmer.

This way of life went into steady decline after the Second World War and, by the early 1960s, had virtually vanished. This was due to a combination of mechanised

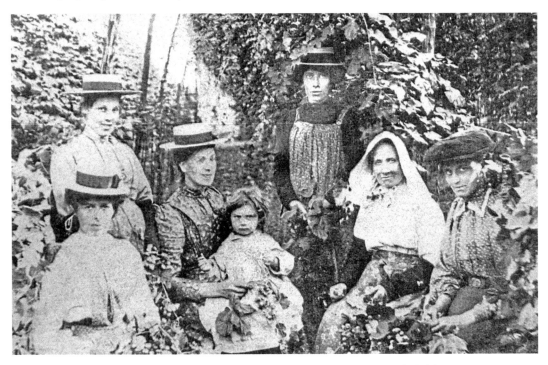

Much of the work on the hop farm was undertaken by women and children.

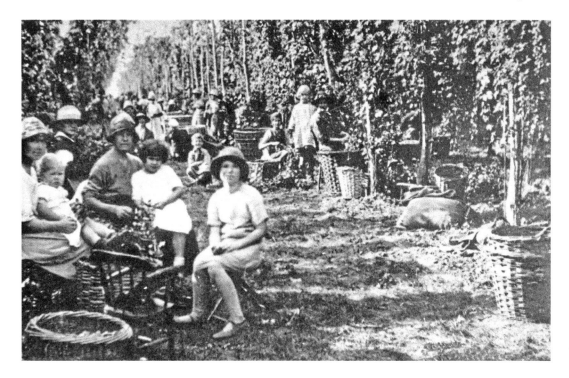

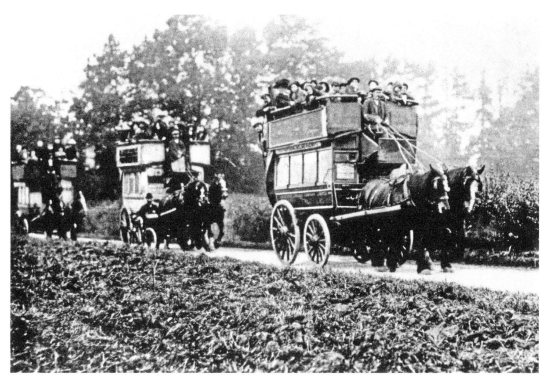

Hop pickers arrive in Kent for the harvest, *c.* 1905. (Shepherd Neame)

methods of farming, falling beer sales and the growing popularity of Continental-style pilsners and blonde beers, or lager, as the often-bastardised British version of this beer style has become known. In most cases fewer, and often foreign, hops would be used. It was a double whammy for UK hop growers.

After several difficult decades, the British hop-growing industry is now in a relatively healthy state, with more than fifty farmers across the country producing them. Although around half of the hops grown in the UK today come from the West Midlands, Kent is still famed for the quality of its crop, and varieties such as East Kent Goldings, Fuggle and Target remain much prized, by both many British brewers, increasingly, and by many American producers of 'craft' beer.

Some 95 per cent of the hops used by Shepherd Neame, Kent's best-known brewery, to make their famous range of cask ales, including Bishops Finger, Masterbrew and Spitfire alongside a range of lagers and stouts, still come from within 25 miles of their Court Street headquarters. A truly remarkable statistic.

The rise and fall and rise of Kent brewing

The story of brewing in Kent is the story of a once mostly domestic chore – the making of ale, often by the woman of the house – that was transformed into a substantial industry once the hop had become established. It is the story of the boom years of the late eighteenth and much of the nineteenth centuries, when Kent's close proximity to London and plentiful supplies of hops made it one of the brewing centres of England.

It is not by chance that the rather grand Hop Exchange, built in 1867 and now Grade II listed, was located in London's Southwark Street. This was the district of London from which pilgrims would set out on the long road to Beckett's shrine in Canterbury, and it made sense to have a single market for the dealing of hops in the capital situated here. The hops would have arrived by train at nearby London Bridge station or would have been delivered via the Thames. The surrounding area, the Borough, once housed countless hop warehouses.

Meanwhile, Kent's location close to mainland Europe also gave the brewing industry in the county a big boost due to its vital defensive role during the Napoleonic Wars, when French invasion seemed imminent. There were thousands of troops stationed in the Medway towns and at ports such as Dover, not to mention the hordes involved in naval and maritime occupations. Where there are soldiers and sailors, there will always be a demand for beer.

According to Manfred Freidrick in his *Gazetteer of the Breweries of the British Isles which have been in Operation since 1875,* as the Victorian age drew to a close there were some 120 breweries in Kent. In East Kent alone, Canterbury could boast six, Ramsgate five and Margate four. Elsewhere Faversham had three breweries, while Broadstairs and Sittingbourne had two each.

It was much the same story elsewhere in the county. Freidrick estimated that there were seven breweries in Dover, six in Gravesend and eight in Maidstone. Tunbridge Wells had five. However, the number was already in decline in the late nineteenth century and that decline would increase after 1900 due to a combination of 'merger' and takeover.

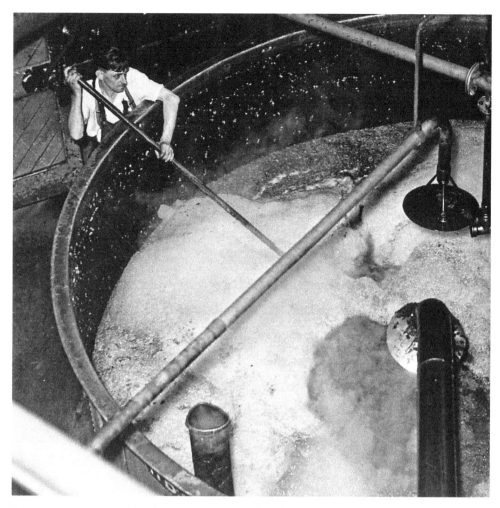

Brewers in action at Shepherd Neame just after the Second World War.
(Shepherd Neame)

The brewing landscape in Kent changed dramatically after the Second World War. A so-called 'big six' of national brewers started to emerge, who were ruthless in their policy of buying up and closing down smaller regional brewers. More often than not, this was done to acquire the tied public houses owned by these regional breweries and, in the process, increase the number of outlets for the bland national brands that the big six saw as the future of British brewing. It also meant that local beers and local brewers, names familiar to generations of drinkers, started to disappear, often overnight. There was clearly little place in the cut and thrust of modern brewing commerce for sentiment.

It all came to a head in Kent in 1990 when the Whitbread Fremlins brewery in Faversham closed. That left Shepherd Neame, located directly opposite in Court Street, and a handful of microbreweries as the only surviving vestiges of an industry that had once been among Kent's biggest.

Brewers from Kent celebrate the new hop harvest.

Wort is the result of combining crushed malted barley and hot water.

This book aims to look at certain aspects of Kent's brewing history and, more pertinently perhaps, at the brewing scene in the county today. Since the dark days of the early 1990s, there has been a welcome renaissance of brewing in Kent, with a host of microbreweries popping up alongside Shepherd Neame, who are still with us and still proudly independent.

Kent is also the birthplace of the micropub, a phenomenon that, alongside the microbrewery and craft beer boom, has shown that, while overall sales of beer might be in decline (although that decline would appear to be plateauing), many people are becoming more discerning, and for that matter more principled, in the beer they choose to drink.

The first micropub was opened by Martyn Hillier in the tiny village of Herne back in 2005. It was housed in a former butcher's shop and, thanks to a change in the licensing laws courtesy of the Labour government in 2003, he was able to convert it into a truly local alehouse. He called it the Butcher's Arms and hasn't looked back since. Indeed, since Hillier opened for business, one of Herne's two traditional pubs has perished.

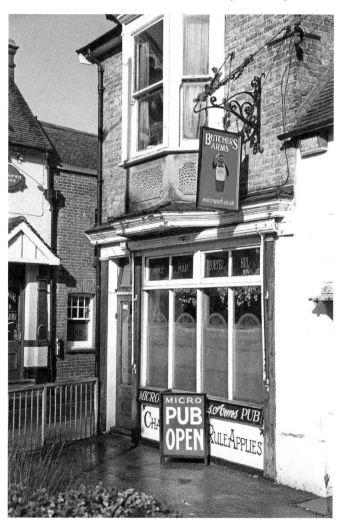

The Butcher's Arms, Herne, was the very first micropub.

There are now almost 200 micropubs across the country and the county of Kent is recognised as the epicentre of a movement that is transforming the way in which many people chose to drink beer and, indeed, the way in which beer is sold.

After decades of conglomeration, homogenisation and, frankly, blandness, we find ourselves in an age where small is beautiful once again and people are searching out distinctive craft and artisan beer. And Kent, the home of the hop, is at the forefront of this revolution.

<div align="right">Johnny Homer</div>

The term barrel, used throughout this book, refers to a British Brewers Barrel, which equals 36 gallons, or 288 pints. A firkin is a cask containing 72 pints.

North Kent

It comes as no surprise that, as the county town of Kent, Maidstone was for many years the centre of brewing in the region. Even in the mid-nineteenth century, when local independent brewers were disappearing at an alarming rate, Maidstone could boast eight breweries. Just before the First World War, there were still six big brewers in the town.

Without doubt the most famous Maidstone brewery and, alongside Shepherd Neame, the most famous name in Kent brewing, was Fremlins; they are remembered fondly for their famous elephant logo. Started with modest resources by Ralph Fremlin in 1861, after he bought at auction the run-down Pale Ale Brewery in Earl Street,

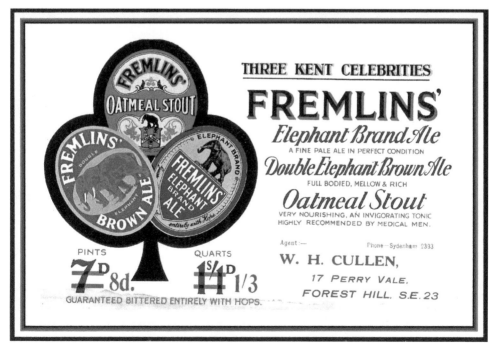

Fremlins advertisement from the 1930s.

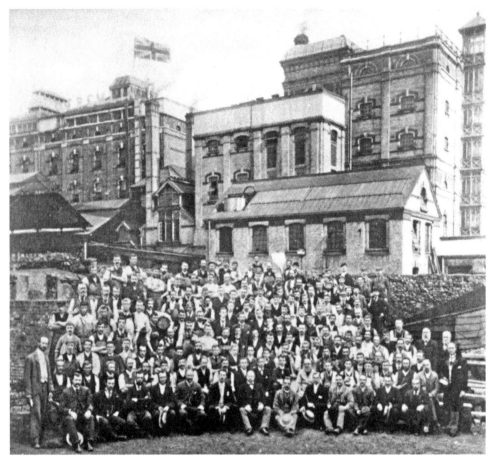

Fremlins staff outside the brewery in 1897.

previously home to the Heathorn Brewery since at least 1790 Fremlins would go on to become the biggest brewer in Kent.

Fremlin, only twenty-eight at the time of his initial purchase but already equipped with considerable experience of working in the brewing industry, saw early-on the potential of bottled beer, particularly for home consumption. This early success enabled him to expand quickly and, just two years later, he made his first acquisition by swallowing up Baldwin, Holmes & Style, a smaller Maidstone brewer also in Earl Street.

Brewery takeovers

In 1871, now working alongside his brothers Frank, Richard and Walter, Ralph Fremlin oversaw the construction of a new brewery complex. By 1881, having won a reputation for the quality of their pale ales, the company was supplying beer throughout Kent and further afield in the south east, with offices in Brighton, Hastings and even London.

As Lesley Richmond and Alison Turton detail in their book *The Brewing Industry: A Guide To Historical Records,* following Ralph's death in 1910, Fremlins Brothers Limited (as the company was known from 1920) continued to buy out fellow Kent

Surviving Fremlins glass from the Bat & Ball pub in Canterbury.

breweries. They bought Canterbury's Northgate Brewery in 1923 and Leney's of Dover in 1926. Fellow Maidstone company Isherwood, Foster & Stacey were acquired in 1929, a deal that included over 150 tied public houses.

Perhaps Fremlins's biggest acquisition came in 1949 when they 'amalgamated' with George Beer & Rigden, who had substantial brewing operations of their own in Canterbury and particularly Faversham. However, less than twenty years later, with the so-called 'big six' snapping up many regional brewers, Fremlins themselves were taken over by Whitbread. The deal included some 800 tied pubs.

Brewing continued both in Faversham and Maidstone but, in 1972, the famous Earl Street brewery was closed. The brewhouse, which had produced so much beer over so many years, was demolished in 1976. Since 2005, part of the site has housed the Fremlin Walk shopping centre, which incorporates the original brewery entrance, dated 1887. However, the featured clock is not the original but a replica supplied by Maidstone Rotary Club. If you look closely, an original brewery weather vane also survives, complete with golden elephant.

Brewing ceased at the Whitbread Fremlins brewery in Faversham in 1990, production moving first to the Flowers Brewery in Cheltenham and then to the Castle Eden Brewery, County Durham, both many miles from Fremlins's spiritual Kent homeland. As Whitbread sold their brewing interests to concentrate on coffee shops and budget hotels, both the Fremlins name and Fremlins beer sadly disappeared.

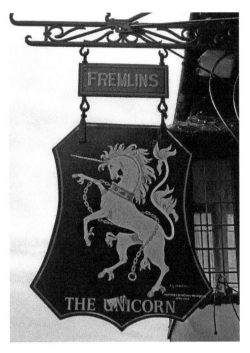 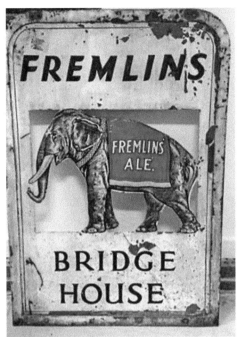

Above left: Surviving Fremlins sign at the Unicorn in Canterbury.

Above right: The famous Fremlins elephant logo.

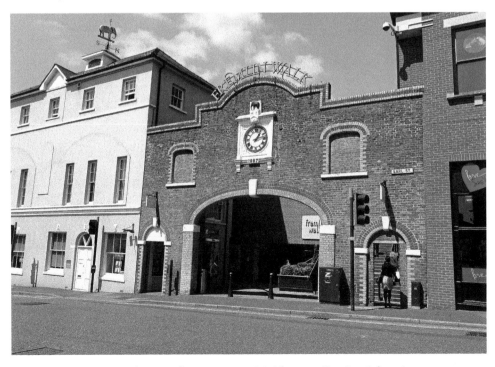

Surviving entrance to the Fremlins Brewery, Maidstone. (Louise Adams)

Jude Hanbury

Although Fremlins were the biggest and best known of the Maidstone brewers, there were several others that enjoyed their moment in the limelight. Among them were Style & Winch who, for a time, were reckoned to be the second biggest brewer in the county.

They were formed in 1899 after a merger between Winch & Sons of Medway and Maidstone's Style & Company. The new company expanded quickly and had a keen appetite for taking over smaller operations, including Vallance of Sittingbourne and Henry Simmons of Hadlow, both in 1905. They later bought Ashford's Lion Brewery (1912) and Rochester's Steam Brewery (1918), also acquiring two London brewers, the Tooting Brewery in 1907 and the Royal Brewery in Brentford in 1922.

Style & Winch's last major acquisition was the Dartford Brewery in 1924. Perhaps this was one takeover too many for, five years later, London came calling and Style & Winch themselves were gobbled up by Barclay Perkins, who would later evolve into Courage, one of the big six. Brewing continued at the famous riverside brewery in Maidstone until 1965. Its buildings were finally demolished in 1976.

Mention must also be made of Jude Hanbury, based in the Maidstone village of Wateringbury. The company was formed in 1870 when John Beale Jude's Kent Brewery, which originated sometime in the 1830s, went into partnership with Ernest Hanbury – a member, no less, of the famous London brewing dynasty of Truman, Hanbury and

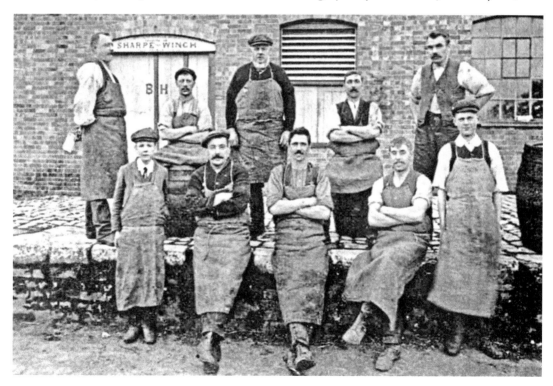

Staff at Sharpe & Winch, Cranbrook, in 1920. Leney's of Dover bought the company in 1928.

Goacher's favour a
traditional-style approach to
marketing.

Buxton. Like Style & Winch, although on a lesser scale, they expanded by buying out smaller brewers, but were themselves consumed by Whitbread in 1930.

It was at the Kent Brewery, incidentally, where a young Ralph Fremlin served his brewing apprenticeship. John Beale Jude was his uncle. All of this highlights how great a part Wateringbury, a small village that today has a population of just 2,000, has played in the brewing history of Kent.

Maidstone today

Although there have been some particularly barren years along the way, the brewing scene in and around Maidstone today is a vibrant one.

The start of this renaissance can be traced back to 1983 when, after a gap of eleven years, brewing returned to the county town when Phil and Debbie Goacher started the brewery that bears their name, originally at the Bockingford Brewery in Loose. As demand rose, they moved in 1990 to a site in Tovil, where a modern brewing plant was set up, with production rising to twenty-one barrels a week. More than thirty years since they started, they continue to brew exceptional Kentish ales made almost entirely from Kentish ingredients.

Goacher's is very much a family concern and, these days, son Howard is also involved in the running of the company. Featuring traditional-style labels, their range includes a light ale, a dark ale and a wonderful interpretation of an Imperial stout. They even produce a mild, which was first brewed to mark the company's fifth anniversary. Good stuff all round, in fact.

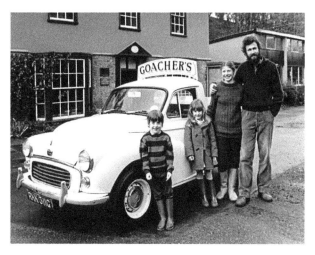

It's a family affair for Goacher's Brewery, *c.* 1983.

If Goacher's are the grand old lady of Maidstone brewing, then a trio of fellow microbreweries that have sprung up over the last few years represent the new kids on the block.

The Musket Brewery was set up at Loddington Farm, Linton, in October 2013 and has gone from strength to strength since. In the neighbouring parish of Coxheath, back in the eighteenth century troops would train in preparation for a feared French invasion from across the Channel. This inspired the brewery's name, not to mention several of their ales – notably, Flintlock, Muzzleloader and Fife & Drum.

The Maidstone Brewing Company was set up in 2014 by David Davenport, landlord of the Flower Pot pub in Sandling Road, Maidstone, and his friend Robert Jackson. Standing on part of the old Style & Winch site, and brewing on a four-barrel set-up, they produce some splendid artisan ales that have seen them pick-up a slew of CAMRA awards. The beers are sold in the Flower Pot, naturally, but have also made guest appearances elsewhere.

Another company in the Maidstone area who started boiling up their copper in 2014 are the Rockin' Robin Brewery in Boughton Monchelsea. Robin Smallbone, with twenty-five years of brewing experience, initially produced only three firkins of beer a week and was overwhelmed with the positive response.

Once business partner Stuart Osgood was on board, Rockin Robin really took off, increasing brewery capacity to fifteen barrels. Their beers, including such wonders to behold as session favourite Hoppin Robin and strong pale ale Really Rockin, are some of the most distinctive in cask I've tasted in a while.

These are busy times at the Maidstone Brewing Company.

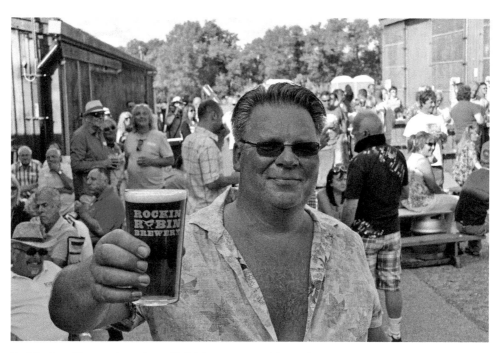

Robin Smallbone, founder of Maidstone's Rockin Robin.

Regulars from the Paper Moon, Dartford, on a visit to the Rockin Robin Brewery.

The brewery is also keen to engage with its customers. When they produced a 'bespoke' beer for the Paper Moon in Dartford, a number of the pub's regulars attended to witness the special event and a good time was had by all.

To round off the story of brewing in the Maidstone area today, it's worth mentioning the Whitstable Brewery. Despite their name, they actually brew out of the former Swale Brewery at Grafty Green and have been doing so since 2002 thanks to the Green family, who own and run several businesses in the Whitstable area.

A Rockin Robin Brewery delivery arrives at the Lady Luck.

From the brewery emerges some wonderful beers, including a unique raspberry wheat beer, a very distinctive Kentish pilsner and an Oyster Stout that is full of character. The man overseeing operations is Rafik Abidi, who was formerly with Shepherd Neame.

Incidentally, the current Whitstable Brewery should not be confused with the old Whitstable Brewery, which was located in Oxford Street, roughly opposite where today's public library stands.

Chatham

With the royal dockyard established in Chatham by Elizabeth I in 1568, it comes as no surprise that there was no shortage of people in the Medway towns looking to quench their thirst. The area's brewing industry went through an unprecedented boom during the eighteenth century as thousands of marines and troops were stationed there in preparation for a possible French invasion.

Then there was the small matter of several thousand men employed in the dockyard. Soldering and shipbuilding are notoriously thirsty occupations.

Among the many Medway breweries that once thrived were Budden and Biggs, based in the high street, Strood. They started as Biggs Brewery in around 1850, founded by Joseph Biggs, and in 1897 became Budden & Biggs when James Budden, a wine merchant from Chatham, joined the company. For a period during the mid-eighteenth century, they proclaimed themselves the Strood Steam Ale Brewery. Even though Shepherd Neame had been using steam as early as 1789, when Biggs started using it more than fifty years later it was still considered cutting edge and very much something to shout about. The company were bought out by Ind Coope, the famous Romford brewer, in 1931. Ind Coope acquired more than sixty pubs in the deal and brewing ended in Strood in 1938.

The Troy Town Brewery were based in Victoria Street, Rochester, where they had been producing noted ales since 1750. They grew slowly through the early and mid-nineteenth century, and invested in steam power as part of a huge modernisation programme in 1860. As several Kent brewers had done before them, they changed their name to reflect this, becoming the Troy Town Steam Brewery.

Soon after ownership of the company changed hands, something that would happen again in future years. In 1906 they bought out the Frindsbury Brewery and, in 1913, started using electricity alongside steam. However, in 1918, on the eve of the end of the First World War, they were swallowed up by Maidstone's Style & Winch, who promptly closed the Victoria Street brewery.

Edward Winch & Sons of Chatham, as detailed elsewhere in this chapter, merged with Maidstone's Style and Co. to form Style & Winch in 1899, after which brewing ceased in Chatham.

Charles Arkcoll's Lion Brewery, in the high street, kept brewing alive in the town until around 1912. The company's pub estate was later acquired by Style & Winch.

Given Chatham's rich maritime history and strong connections with the Royal Navy, it is somehow fitting that the only people making beer in the town today are the Nelson Brewery, who work out of an industrial unit based in what is now the Historic

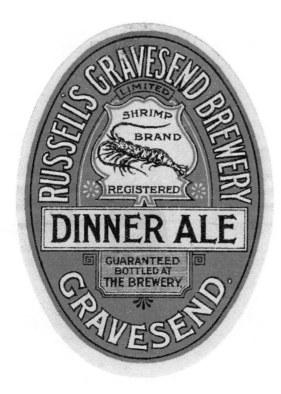

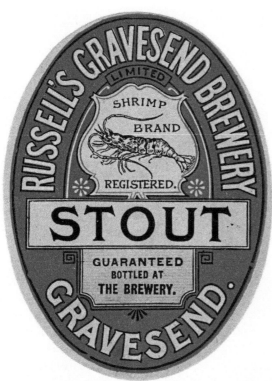

Above and below: Russells of Gravesend were famed for their Shrimp Brand beers. (Labologist's Society)

Dockyard. Founded in 1995 as the Flasgship Brewery, it became the Nelson Brewery in 2003. Lord Nelson's flagship was built at the royal dockyard, and England's greatest naval hero clearly inspires such delights as Admiral IPA.

A selection of seasonal beers, grouped under the umbrella name of Trafalgar Ales, are all named after ships that fought in the famous naval battle at which Nelson heroically lost his life.

Moving towards London, Dartford and Gravesend were two of Kent's most heavily industrialised areas, with the Thames crucial to the economy of both.

For many years, the most famous brewery in this neck of the woods was Russell's Gravesend Brewery in West Street, renowned for their Shrimp Brand beers. Shrimp fishing played a major part of the economy for many years in this neck of the woods, with the distinctive Bawley boats a common sight.

A brewery, Pine & Heathorn, had stood in West Street until it was acquired by the Russell family in 1858. By 1909 they had almost completely redeveloped the site into a state-of-the-art operation, boasting of the 'purity and quality' of their beer, which included brown ales, stouts and even a 'dinner' ale. In a scenario common to the brewing industry, they expanded by swallowing up a number of smaller breweries (including the East Street Brewery, also in Gravesend, and the Wilmington Brewery in Dartford) until, in 1932, they themselves were gobbled up by London giants Truman's, the famous Black Eagle consuming the poor old Shrimp. By 1935 brewing had ceased at West Street, although bottling continued here for a while, and the brewery was finally knocked down in 1950. The maltings have survived, however, although these have been converted, almost inevitably, for residential use.

Russells were not the only Gravesend brewer to be snapped up by one of the big London companies. Walkers in Wellington Street, perhaps better known as Walker & Sons, were bought in 1905 by Charringtons. Brewing continued in the town until 1928 when, after suffering damage in a fire, the brewery was closed and, some years later in 1936, finally demolished.

Dartford and beyond

Gravesend itself these days appears to be brewery free, but the noble art is not completely absent from the area. The Dartford Wobbler Brewery in South Darenth, Dartford, have been brewing since 2003 using their own unique strain of yeast, which took thirty-eight attempts to perfect. They brew traditional-style ales for cask and bottle.

The men behind the beer are John Millis and his son Darren. In December 2014 the brewery provided four casks of ale for sale in the Strangers' Bar at the Houses of Parliament after an invite from Dartford MP Gareth Johnson.

A Dartford Wobbler, in case you were wondering, is not a rare breed of bird fond of winter berries and the safety of the hedgerow, but the nickname given to the intrepid Edwardian cyclists who would ride around the Darenth Valley, making several stops along the way to wax their moustaches and take liquid replenishment. The more they replenished, the wobblier they got. The brewery logo features a penny farthing.

In Swanley Village, Brew Buddies are breaking with British beer convention a little by producing a range of beers that are naturally unfined. Finings, a solution added

Inside the Dartford Wobbler Brewery, South Darenth.

to cask beer to draw down yeast and give a clear brew, are usually obtained from the swim bladders of fish, often sturgeon. Brew Buddies, however, are keen to fly the flag for 'hazy' beer and emphasise the positive health benefits of yeast.

Not a million miles away in Swanscombe is the Caveman Brewery, located in part of the cellar of the George and Dragon pub, London Road. Launched in August 2012 with just a single beer, Citra, a few years down the line they have a core range of four cask ales and a number of seasonal brews that are certainly far from primitive when it comes to quality and variety.

Started by Nick Bryam and James Hayward, the growth of Caveman the brewer is linked with a change in fortune for the George and Dragon pub. This sturdy old Victorian boozer apparently didn't have the best of reputations but, when it was acquired by Bob and Bron Veal, these intrepid new licensees set about changing the pub's image. To do this they changed the beer on offer.

Out went bland national brands and in came beers from craft and microbrewers; allowing Caveman to brew in their cellar is a natural progression. It is also the reason why the pub has found itself included in the illustrious pages of CAMRA's *Good Beer Guide*.

In addition to producing their own range of fine beers, Caveman have been involved in several collaborations with other microbrewers, notably the reborn Truman's, once famously of the Black Eagle Brewery, Brick Lane, but now of Hackney Wick, east London, and the Devilfish Brewery, based in Hemington, Somerset.

James Hayward and Darren Turner of the Caveman Brewery.

The George and Dragon, Swanscombe.

South Kent

Hythe is a sleepy Kent coastal town, famous today for the Romney, Hythe & Dymchurch Railway; however, its place in brewing history is ensured as the birthplace of Mackeson Stout, described by the late, great beer writer Michael Jackson in his seminal *Great Beer Guide* as, the 'world's most widely known sweet stout'.

The beer was developed and brewed by Mackeson, who, prior to 1907 when the redoubtable and durable Milk Stout was first sold, were known for a range of pale ales, light ales and stouts. What would later become Mackeson was founded in 1669 by the well-connected James Pashley, a baron of the Cinque Ports and also one of the

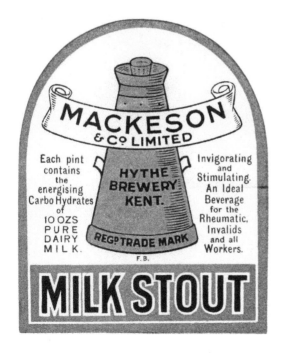 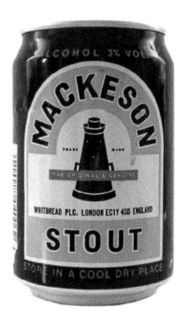

Mackesons was invented in 1907 and is still brewed today.

canopy-bearers at the 1685 coronation of James II, alongside Samuel Pepys, the MP for nearby Sandwich. The brewery was initially based in Hythe's high street and grew substantially over the years.

On Pashley's death, the business was acquired by the Friend family and, in 1801, they sold it to brothers Henry and William Mackeson. The Milk Stout that would put the brewery, and indeed Hythe, on the map was developed in 1907, and saw a team of brewers work alongside a dietician to come up with a 'healthy' beer.

Birth of Milk Stout

The stout was unique at the time for its use of lactose, or milk sugar, which was added to the wort after the initial mashing stage, when malted barley and hot water are combined. This lactose was unfermentable and so, unlike other natural sugars obtained in the mash, would not be converted into alcohol when yeast was added later in the brewing process. The lactose also gave the stout a long-lasting sweetness.

To emphasise the beer's supposed health benefits, an early claim made by Mackeson was that 'Each pint contains the energising carbohydrates of ten ounces of pure dairy milk'. To this day the beer's label features the image of a milk churn.

Popularity of Milk Stout

In 1929 Mackeson were snapped up by Whitbread, and initially the new owners considered stopping production of Milk Stout altogether. But, after tweaking the recipe, Whitbread soon had a huge success on their hands and, by the 1960s, more than half of all the beer they were brewing – a not inconsiderable amount – was Mackeson Milk Stout, advertised on television with the catchphrase 'Mackeson – it looks good, it tastes good and, by golly, it does you good'. For a time Mackeson even gave Guinness a run for its money in the UK marketplace.

Whitbread closed the Hythe brewery in 1968, with Milk Stout by this time brewed at several locations outside Kent. Most of the original Mackeson brewery was demolished, although the old malt house in the high street was spared the ball and chain and, since 1974, has housed an antiques market that still thrives.

Mackeson Milk Stout is still brewed, these days by InBev, the largest brewer in the world. Never an especially strong beer, today it has an ABV (alcohol by volume) of just 2.8 per cent. Who, one wonders, is drinking the stuff?

Mackeson's departure from Hythe was a huge blow to the local economy and it would be more than forty years before brewing returned to the town. In 2011, childhood friends Daryl Sanford and Martyn Playford opened the Hop Fuzz Brewery, producing a range of beer that encompasses traditional styles such as bitters and stouts, alongside more modern offerings that include an American pale ale and a modern-style IPA, loaded with Columbus hops.

Brewing on a twelve-barrel set-up, Hop Fuzz are also proud of their eco-friendly credentials. Spent grain from mashing is given to the nearby Port Lympne Zoo, where it is used as animal feed. Local pigs, meanwhile, get to eat any excess yeast after fermentation. Lucky pigs!

Hop Fuzz have brought brewing back to Hythe.

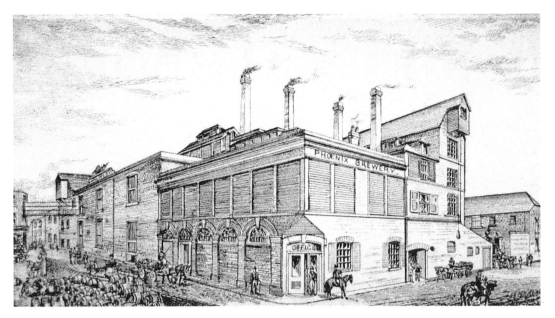

Throughout the nineteenth century, Dover's Phoenix Brewery was among Kent's biggest. (Dover Museum & Bronze Age Boat Gallery)

Brewing in Dover

There is an argument to be made that, for much of the nineteenth century, Dover was the brewing capital of Kent. Certainly records show that in 1850 there were eight breweries of varying size operating here and, outside of the port's numerous maritime-related activities, brewing was probably Dover's biggest industry. This isn't a huge surprise when one considers that Dover's population was large and growing, swollen by thirsty military and naval personnel.

The most famous, and largest, of the Dover breweries was the Phoenix, which started life around 1740 under the ownership of a Mr Clements. It was bought by the Walker family early in the nineteenth century and traded as Thomas Walker & Sons, one of the earliest brewers to incorporate steam into the brewing process. In 1859 the Phoenix was acquired by the Leney family, with Alfred Leney as the company figurehead.

Leney's brewed a celebrated selection of 'Dover Ales' and stouts, with their famous phoenix trademark known widely across Kent. A proud boast made for their beer was that it was 'Guaranteed Bittered Entirely by Hops' and they enjoyed considerable success and growth, buying the Canterbury brewer Flint & Co. in 1904 and increasing their pub estate to around 160 licensed premises. All of this made the Leneys one of Dover's wealthiest families. After his death in 1900, Alfred Leney's will had a gross value in excess of £188,000.

Growth and merger

Originally sited in Dolphin Lane, a grand brewing complex emerged over many years and included a 120-foot-high chimney, erected in 1913, that dominated the local landscape and stood until 1959, when it was dismantled brick by brick. Swish offices

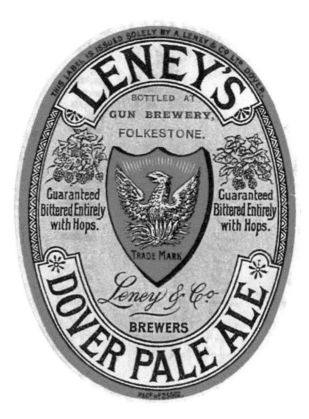

Leney's beer was renowned throughout the south east. (Labologist's Society)

were opened in nearby Castle Street towards the end of 1890 – 'the finest and best arranged business premises in Dover', according to one newspaper of the day – and, all told, the company occupied more than 5 acres of prime land in the town centre.

Leney's merged with the Maidstone brewer Fremlins in 1926. There was already a connection of sorts between the two as, many years beforehand, Alfred Leney had married Catherine Fremlin, the eldest daughter of James Fremlin. Following the merger, brewing ceased at the Phoenix site in 1927 and the company started to trade under the Fremlins name. Bottling continued in Dover until 1950.

Leney's were the biggest and most famous of the Dover brewers, but there were others worthy of mention.

The Kindsford Windmill Brewery, widely known as the Buckland Brewery, operated from the 1820s until the late nineteenth century, standing on the corner of Coombe Valley Road, formerly Union Street, and London Road. The windmill itself, of the late eighteenth century, was a local landmark and would have been used to power both the malt mill and the pump, which extracted water from the on-site artesian well. When brewing stopped here, G. S. Palmer's coachworks occupied the site.

The Diamond Brewery was based on the Folkestone Road, Maxton, and was founded in around 1850 by Henry Worthington. It passed briefly to John James Allen in 1889, although ownership changed constantly until 1908, when it was swallowed up by Leney's. The seemingly unstoppable Leney's also acquired the Poulter's Castle Brewery, Biggin Street. Meanwhile the Wellington Brewery, in a former paper mill in London Road, close to the Buckland Brewery, started in around 1850 and operated until 1890, although some of the old brewery buildings survived until the early 1960s.

Brewers are a little thinner on the ground in Dover today, although the Tir Dha Ghlas Brewery, part of the Cullins Yard bistro and wine bar in Cambridge Road, has been producing some interesting cask ales since 2012.

Folkestone and Deal

Folkestone also had a number of independent brewers, which sadly disappeared long ago. The Gun Brewery in Cheriton Road was certainly brewing by 1844, but might have been in operation as early as 1821. Its name was inspired by a huge naval gun located in Folkestone in the Napoleonic era. The Gun Brewery was bought by Leney's in 1898 and subsequently closed.

The Atlas Brewery in Tontine Street started in 1734 but was another victim of takeover frenzy, bought and closed by Mackeson in 1886.

In Upper Walmer, just outside Deal, the Walmer Brewery on the Dover Road was a major local employer from 1816 through to the mid-1970s. It was founded by Edmund Thompson in 1826 and thrived as Thompson & Sons. It was bought in 1867 by John Matthews, with the Thompson & Sons name retained. Matthews greatly expanded and modernised the company. They produced a range of beers that included light pale ales through to much stronger fare, including 'X', 'XX' and even an 'XXX' ale.

In 1951 Thompson & Sons were taken over by London's Charrington and, two years later, brewing at Dover Road ended, although bottling continued and the premises

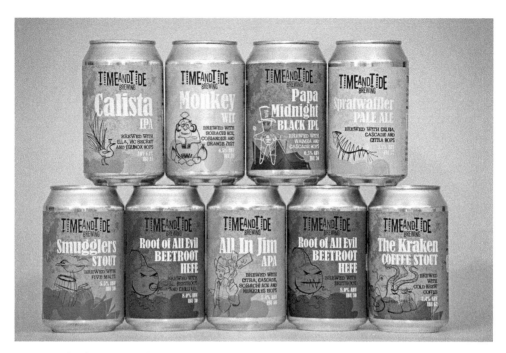

Brewing for key keg and can, Time & Tide are flying the craft beer flag in Kent.

were also used as a distribution plant until 1972. The brewery was finally demolished in 1978 after standing idle for several years.

The brewing landscape in this part of Kent had been a pretty bleak one for the best part of six decades, but the picture looks much brighter today.

Sandwich, despite its modest size and small population, has a rich beer legacy. However, throughout the eighteenth and nineteenth centuries, the town saw a number of brewers come and go, names that once enjoyed local favour but are now just footnotes in history. These include the Denne Brewery of Jail Street, Gillow & Wareham, the Hoile Brewery in Lower Street and the Nethersole Brewery, once in New Street.

After many years without any brewing activity, towards the end of 2013 Time & Tide started life. Early brews were well received and, in October 2015, they moved to a converted barn in Eastry, where they now brew on a twenty-barrel set-up. In addition to producing a popular core range of ales such as All In Jim, an American pale ale, and their much-lauded Smuggler's Stout, they also brew a beer with coffee beans (Kraken Coffee Stout) and one featuring beetroot (Root of All Evil beetroot Hefe). This is craft brewing, Kent style.

In December, 2015, Time & Tide brewed a beer called Barnes on Fire, described as a 'homage' to Chris Barnes, landlord of the Berry pub in Walmer.

Perhaps one of the more unique brewing operations in Kent can be found at Personage Farm, Sutton-by-Dover, from where the Ripple Steam Brewery produce an impressive range of 'artisan craft' ales, including a session best bitter and a black IPA.

Left: The Ripple Steam Brewery use steam in the brewing process.

Below: Ches is the master brewer at the Ripple Steam Brewery.

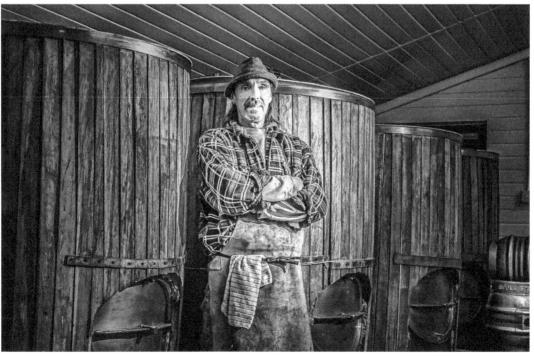

Established in 2011, as the name suggests the brewery use steam during part of the beer-making process, a process they make a point of describing as 'non-mechanised'. There are many brewers throughout the land claiming to use traditional methods of production, but I doubt many are quite as traditional as the Ripple Steam Brewery.

Tenterden then and now

Brewing in the pretty market town of Tenterden can be traced back to 1792, when Isaac and Thankful Cloake set up an operation behind the Vine Inn in the high street. In 1872 the business was taken over by Obadiah Edwards. His sons Fred, Henry and Robert continued his work after his death, with production peaking at 4,000 barrels a year to serve both local hostelries and their own ten-strong pub estate.

However the years immediately after the First World War were to prove difficult for many independent local brewers and, in 1922, the Tenterden Brewery was bought out by Jude Hanbury of Wateringbury, who promptly closed it.

It would be almost ninety years before brewing returned to the area when, in 2010, the Old Dairy Brewery sprang into life. Originally based, as the name suggests, in an old milking parlour, the brewery's distinctive and very drinkable range of ales soon struck a chord with Kent beer lovers. In mid-2014, to meet demand, they relocated to larger premises in Tenterden itself: two Second World War Nissen huts, located just yards from Tenterden station on the Kent & Sussex Light Railway.

With a brewing capacity of thirty barrels, a team led by Glenn Whatman have picked up numerous awards for regular beers such as Copper Top and Red Top, in addition to occasional brews including a green hop beer and the intriguing AK1911, based on a century-old Kentish recipe.

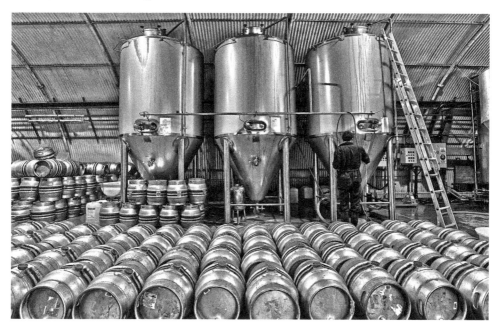

A river of cask ale at the Old Dairy Brewery, Tenterden.

Romney Marsh

One of the more recent additions to the revived Kent brewing scene is the Romney Marsh Brewery, launched in May 2015 as a family-run concern and based in a part of Kent known by many as the 'fifth continent', on account of its remote location. The brewery is a real family affair, run by husband and wife team Matt Calais and Cathy Koester, alongside Matt's parents Brian and Lynn.

The Romney Marsh Brewery is located on Kent's 'fifth continent'.

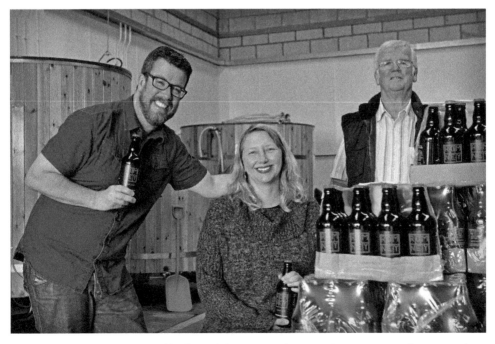

Romney Marsh Brewery staff – *from left*: Matt Calais, Cathy Koester and Brian Calais.

Matt worked in television for many years and his credits include Channel Four's *Come Dine With Me*. Cathy is American-born and has spent time working in parliament and also in the British music industry. Possibly the perfect preparation for a career in brewing.

The brewery's beer is made from British barley and wheat. The hops are a mixture of British and New World, particularly American hops. The beers range from a golden ale and a best bitter through to a distinctive dark beer, the wittily named Cinque Porter.

We will end our look at the brewing scene in South Kent by considering two breweries in the Ashford area, offering very different styles of beer. The Old Forge Brewery is based at the Farriers Arms pub in Mersham and started brewing in October 2010, largely with equipment from the Black Dog Brewery in Whitby, Yorkshire.

Modern design values have been embraced by the G2 Brewery, Ashford.

They started with a two-and-a-half barrel kit; capacity has since doubled, although can sometimes be pushed to six. Their first beer was Farriers 1606 Bitter, still a best seller, and these days their range also includes a ruby ale and a golden ale. Some beer finds its way to local pubs and beer festivals, but the majority is for the Farriers Arms itself, much to the delight of the pub's regulars.

A little nearer to Ashford itself is G2 Brewing, which was set up in 2014 by Oli Hawkins and Sam Straker-Nesbit. They currently brew three beers, Crux, Otava and Vela, that manage to combine elements of traditional cask ale with a craft beer vibe. The beers are slickly marketed and are already proving popular in both Kent and London.

The business was given a big boost when it received £25,000 from the Virgin StartUp scheme. They also have a brewery dog called Joey, who keeps all concerned on their toes.

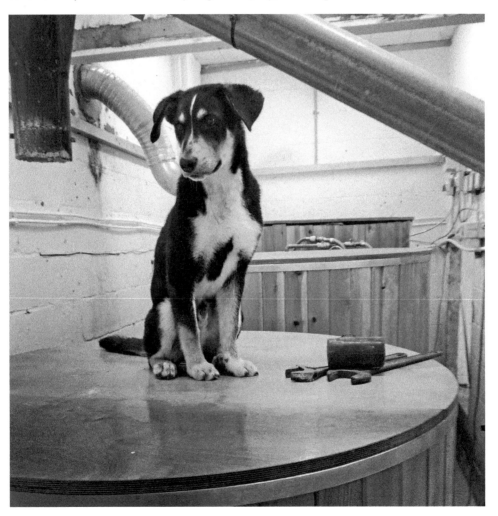

Joey is the top dog at the G2 Brewery.

East Kent

East Kent, which for our purposes covers Canterbury, Herne Bay, Swale, Thanet and Whitstable, is an area with a rich brewing history and a vibrant contemporary scene. Here you will find Kent's sole surviving 'big' brewer, Faversham's Shepherd Neame, in addition to a host of innovative microbreweries.

If you find yourself in the village of Herne, you can squeeze into Martyn Hillier's ground-breaking Butcher's Arms, which opened in 2005 as the very first micropub. East Kent is now a hotbed of similar watering holes, small but essential establishments

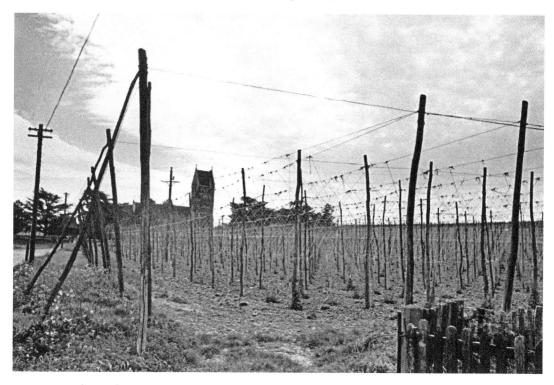

Hops, shown here at Ospringe, have been cultivated in Kent since the sixteenth century.

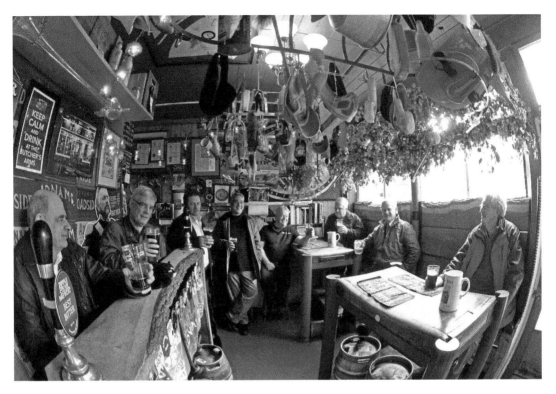

Above: Inside the Butcher's Arms, Herne, the very first micropub.

Left: Martyn Hillier in action at the Butcher's Arms, Herne.

that often support local breweries and continue to thrive, while many traditional pubs, by contrast, continue to sail sometimes choppy waters.

The intrepid toper, if they have a mind to, can easily spend a day or two 'crawling' around the area's micropubs, from the Black Dog, Handsome Sam and Tankerton Arms in Whitstable through to Herne Bay establishments such as the Bouncing Barrel and the Firkin Frog.

Thanet also has a number of these establishments, ranging from the Harbour Arms, the Lifeboat and the excellent Two Halves in Margate through to the Four Candles in St Peters and the Conqueror Alehouse in Ramsgate.

And if this isn't enough to ensure East Kent's place in brewing history, it is widely believed that the very first mainstream cultivation of hops in this country took place at Westbere, just a few miles from Canterbury in the early sixteenth century. A claim to fame indeed, and reason enough as to why CAMRA's Kent Beer Festival takes place each July at Merton Farm, near Canterbury. You can almost hear the hops growing as you sup your ale.

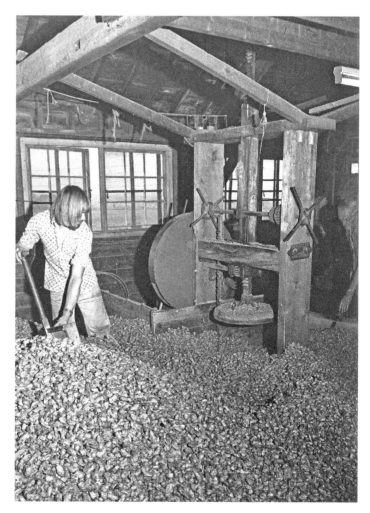

Hops are fed into a hop press, *c.* 1970s. (Shepherd Neame)

Above: A hop machine at Queen Court Farm, Ospringe, *c.* 1960s. (Shepherd Neame)

Left: Freshly picked hops at Queen's Court Farm. (Shepherd Neame)

The rise and fall of East Kent brewing

Of the major breweries in Canterbury, the Dane John Brewery, on the corner of Marlow Avenue, formerly St John's Lane, and Watling Street, had been in operation since 1770, increasing in size over the years to become a substantial operation. Under the ownership of Ash & Co., formerly Ash & Sons, it became famous for its Canterbury Ales, advertised with the proud claim that they were 'brewed from best malt and English hops.'

The brewery closed in 1936, with the site sold and the rather elegant brewery buildings demolished. A large part of the former site, adjacent to Dane John Gardens, today houses a municipal car park, with St Andrew's United Reform Church now on the corner of Marlowe Lane and Watling Street.

Another major Canterbury brewer was Flint & Co. in St Dunstan's Street, who established brewing here in 1797 at Roper House and down the years were known variously as Flint & Kingsford and Flint & Sons. Of the many breweries that once thrived in Canterbury, Flint & Co. had a real air of romance about it, largely due to its location. The brewery was accessed through the mid-sixteenth-century Roper Gate, once the entrance to Place House, the grand residence of the well-connected Roper family.

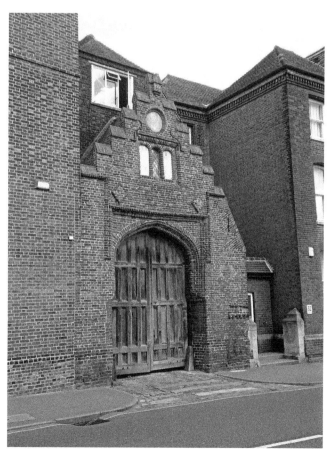

The sixteenth-century Roper Gate, a visible reminder of Canterbury's St Dunstan's Brewery.

A Flint label featuring the Roper Gate. (Labologist's Society)

The gate still stands, a fine example of Tudor brickwork and one of the few visible parts of the Flint operation to survive demolition in 1957. For many years, an image of the gate featured proudly on the labels of the brewery's bottled beer range.

Around 1870, just yards from the brewery in St Dunstan's Street, Frederick Flint built himself a grand house in the Victorian Gothic style. It survives to this day and is now a residential care home.

Flint had been snapped up by Dover's Phoenix Brewery in 1923 and ceased brewing six years later. The Flint name lives on in a few rare examples of surviving brewery livery across the county, including etched windows at the Cricketers in Canterbury and the Two Brewers in Whitstable, and also on the grand exterior facade of the Elephant in Faversham.

Among Canterbury's other notable breweries was the Star Brewery on the corner of Broad Street and Burgate, which incorporated part of the old city wall in its buildings. It was started by George Beer, of the famous Beer brewing dynasty, in around 1850 and, despite being bought by a trio of local businessmen in 1883 for the not inconsiderable sum of £50,000, continued to operate as the George Beer Company. Advertisements from the late nineteenth century show that Beer and Co. operated further afield, with offices in both Eastbourne and the City of London.

Early in 1922 George Beer & Co. and Rigden's of Faversham joined forces in what local newspaper reports of the day described as an 'amalgamation', going on to trade

Frederick Flint's showpiece house in Canterbury, from around 1870, is now a residential care home.

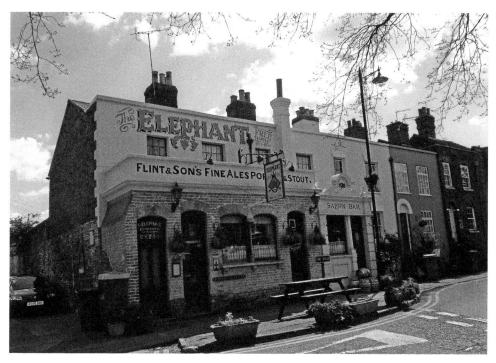

The Elephant, Faversham, was clearly a former Flint & Co. pub.

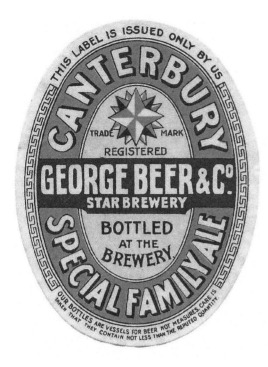

George Beer & Co. were one of
Canterbury's leading brewers.
(Labologist's Society)

successfully as George Beer & Rigden. The Star Brewery was closed and demolished
in 1936, with operations transferred to the Rigden's brewing complex in Faversham.

George Beer, along with several other family members, is buried at St Martin's
Church in Canterbury. The inscription on his gravestone reads:

'George Beer the Brewer, Lies Buried Here, On Earth he was both ale and stout, Death
bought him to his bitter beer, And now in heaven he hops about.'

Brewing renaissance

Traces of Canterbury's once-thriving brewing industry can still be seen in Stour Street,
where the remains of the famous Stour Street Brewery survive. In this neck of the
woods you will also find the aptly named Beer Cart Lane, although the dear old Beer
Cart Arms is now, alas, a restaurant.

After the Second World War, the brewing landscape in Canterbury became an
increasingly bleak one, and by the 1960s there was no brewing industry to speak of.
The picture today, I am pleased to report, is much brighter, thanks to a handful of
microbreweries.

The Wantsum Brewery, in Hersden just outside Canterbury city centre, was set up in
2009 by James Sandy. His first brew was a beer called Fortitude, a 4.2 per cent session
bitter combining English and American hops. It remains one of the brewery's most
popular ales and is among eight regulars and ten seasonal beers produced for both
cask and bottle. Originally brewing on a six-barrel set-up, Wantsum doubled their
capacity in 2012 to meet growing demand.

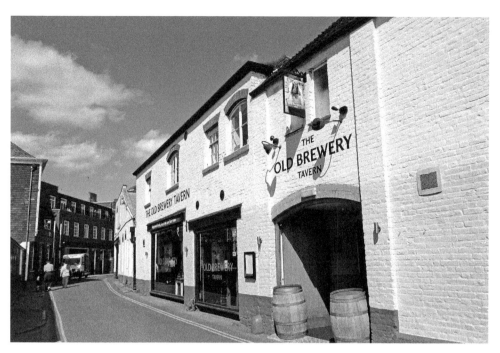

The Old Brewery Bar in Stour Street is a reminder of Canterbury's rich brewing heritage.

Inside the Wantsum Brewery, one of Kent's leading microbreweries.

The names of most Wantsum beers are inspired by chapters in Kent's rich and varied history, and include a golden IPA called 1381, the year of the Peasants' Revolt, and a fine session bitter called More's Head, named after Sir Thomas More, whose head, so local lore has it, resides in St Dunstan's Church, Canterbury.

Also located a few miles from the centre of Canterbury, this time near Chartham Hatch, is Canterbury Ales. Set up in 2010 by Martin Guy, a former finance manager in the world of publishing, the company produce a core range of six real ales named after characters from Chaucer's *Canterbury Tales,* ranging from a session pale ale (Pardoner's Ale, 3.8 per cent) through to a stronger, dark ruby bitter (Knight's Ale, 4.6 per cent). In 2014 Guy's Merchant's Ale stout, 4 per cent, was named overall champion beer for the South East region by SIBA, the Society of Independent Brewers.

Inside the city walls

Perhaps Canterbury Brewers represent the most poignant chapter in the story of the return of brewing to the cathedral city, for they are located within the city walls and practically in the shadow of the cathedral itself.

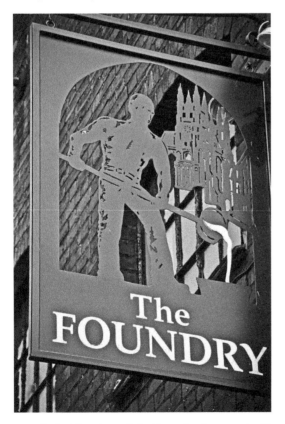

Left: The sign of the Foundry brewpub, Canterbury.

Right: Brewing equipment at the Foundry brewpub.

FOUNDRY BREWPUB
HOME OF THE

CANTERBURY

BREWERS

WHITEHORSE LANE, CANTERBURY
WWW.THEFOUNDRYCANTERBURY.CO.UK

Canterbury Brewers are almost in the shadow of the cathedral itself.

Based at the rear of the Foundry pub in White Horse Lane, housed in a former Victorian iron foundry, Canterbury Brewers was started in 2011 by Jon Mills and Gary Sedgwick. From a modest four-barrel set-up that can be observed from the bar itself, they produce a spectacular and varied array of cask ales and craft beers, with Mills himself and his fellow intrepid adventurer in beer Tom Sharkey doing the brewing honours.

You'll find real innovation here in the shape of a marvellous and occasionally mind-boggling range of beer, from contemporary craft offerings such as the excellent Canterbury Pale Ale and a refreshing black lager through to the best selling Foundry Man's Gold cask ale and the truly awesome Street Lighter porter. For Halloween a few years back they brewed a pumpkin beer.

Things are also on the up in the wider Canterbury district. Close to the village of Herne, based at the Bleangate Brewery, are Goody Ales, set up in 2012 by Karen Goody and Peter McCabe.

They brew a range of traditional cask ales with much emphasis put on local ingredients, including, of course, Kentish hops. The beers are all named, tongue in

Foundry brewers Tom Sharkey (left) and Jon Mills.

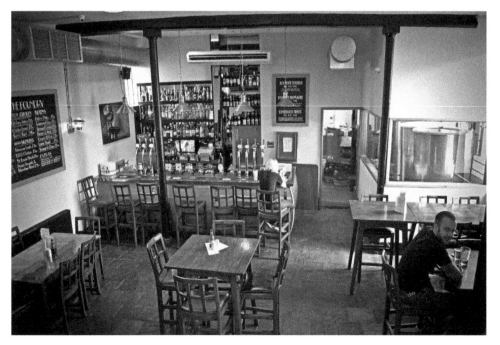

Beer at the Foundry is brewed at the rear of the ground-floor bar.

Goody Ales have been brewing near Herne since 2012.

cheek, with a nod to the good book. The session ale Genesis was named beer of the year at the 2014 Taste of Kent Awards.

Faversham past and present

Considering the size of Faversham when compared to the likes of Ashford, Canterbury, Dover and Maidstone, it is amazing how big a part the town has played in the history of

Left: Original architect's drawing for Shepherd Neame's Court Street offices, 1868...

Below: ...and as they are today. (Shepherd Neame)

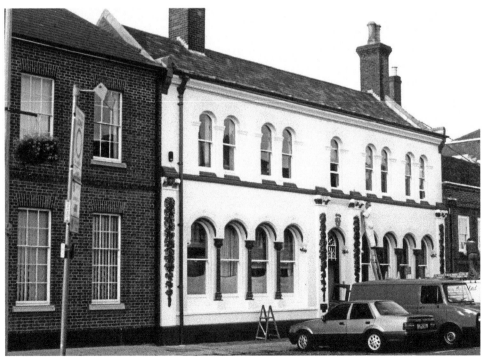

Vintage advertisement for Shepherd Neame. (Shepherd Neame)

brewing in Kent and no history would be complete without a lengthy look at Shepherd Neame, Britain's oldest brewer and one of the country's most successful regional independents.

The company have long given 1698 as the year of their formation but, since celebrating their tercentenary back in 1998, have discovered that brewing at their current Court Street site can be traced back to at least 1570, under the ownership of John Castlock – perhaps even a little earlier. In 1653 the brewery was acquired by Thomas Hilton and, when he died in 1678, it was leased from his executors by Richard Marsh, who bought the brewery outright in 1698. When Marsh died in 1726, the business passed to one of his sons, although he died himself just a year later. His widow Mary remarried and, when her second husband expired, she married again, this time to a local man called Samuel Shepherd.

A landmark year in the company's history was 1864, when Percy Beale Neame, a local hop farmer, joined as a partner and, effectively, Shepherd Neame was born. Neame became sole owner in 1875.

The Neame family are still at helm today. Jonathan Neame is the company CEO while his father Robert is president. It is largely down to the Neame family, and their determination to remain independent, that the company survived the merger and takeover madness of the post-war years.

Tradition and state-of-the-art technology are combined at the brewery today. They produce around 70 million pints of beer a year, using chalk-filtered mineral water drawn from an on-site artesian well. Until 2016 they were still using two oak-lined mash tuns, dated 1914 and 1916 respectively, in the production of such famous cask ales as Bishops Finger and Spitfire. Cutting-edge modern mash tuns are now installed in the brewhouse, which itself dates from 1864 and boasts some exquisite stained glass windows that were installed in the year 2000.

Left: Shepherd Neame's Brewhouse, *c.* 1910 ...

Below: ...and as it is today. (Shepherd Neame)

Vintage advertisement for Shepherd Neame. (Shepherd Neame)

Part of a fifteenth-century drain discovered during work at Shepherd Neame, Faversham. (Shepherd Neame)

Nineteenth-century
earthenware beer jugs for
Rigden's and Shepherd
Neame.

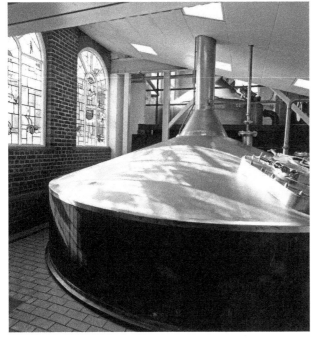

Lauter tun in
Shepherd Neame's
Millennium Brewhouse.
(Shepherd Neame)

Right: Oak mash tuns, from 1914 and 1916, at Shepherd Neame. They were replaced in 2016. (Shepherd Neame)

Below: Digging out the mash tun at Shepherd Neame, 1946. (Shepherd Neame)

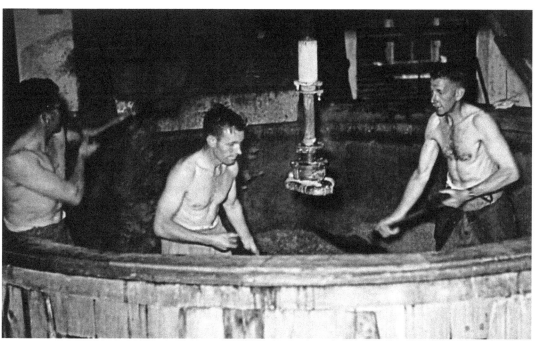

Above: Shepherd Neame was
one of the first breweries
to use steam in the brewing
process, seen here in 1940.
(Shepherd Neame)

Left: The Street runs
through the heart of the
Shepherd Neame Brewery.
(Shepherd Neame)

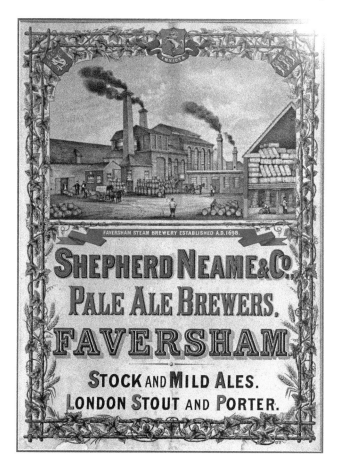

Nineteenth-century advertisement for Shepherd Neame. (Shepherd Neame)

After Whitbread of London, Shepherd Neame were the second brewery anywhere in the world to incorporate steam power in the brewing process, courtesy of a sun and planet engine installed in 1789, made by the famed Boulton & Watt of Birmingham. The company were so proud of this cutting-edge technology that they were briefly known as the Faversham Steam Brewery, a name revived for their contemporary Whitstable Bay range of beer.

Rigden's

Standing directly opposite Shepherd Neame for many years was Rigden's, another of Kent's most famous breweries. The company was founded in Faversham by Edward Rigden, probably in around 1770, and grew steadily.

Ownership of the brewery was passed down through the Rigden family and an interest in banking, combined with the brewery business, made them wealthy. Between 1874 and 1884, they built a huge site in Faversham, much of which survives. It featured a substantial malt house and sizeable brewing operation.

The older parts of the brewery now enjoy Grade II listing and are some of the finest surviving examples of nineteenth-century brewery architecture in the country. The former malt house was converted into a Tesco supermarket in 1995, with many of

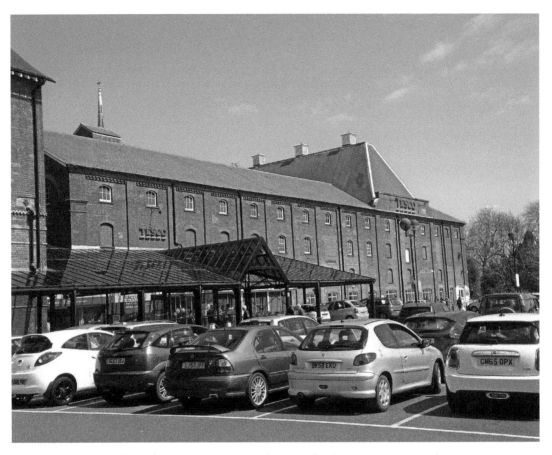

Much of the old Rigden's Brewery, Faversham, today houses a supermarket.

the other surviving buildings now providing warehouse-style living accommodation. Other former brewery buildings house an Italian restaurant and a community centre.

In 1921 Rigden's merged with Canterbury's George Beer to form George Beer & Rigden's. It became a public company in 1927, boasting a portfolio of around 250 pubs. However in 1949 it was bought by the giant Maidstone brewer Fremlins. Brewing stopped at the Faversham site in 1954 but resumed in 1961.

In 1968 Fremlins were acquired by Whitbread, one of the so-called 'big six' of British brewing at the time. Initially the future looked bright for the Faversham brewery, with some major investment made by Whitbread, but, in May 1990, the site was closed with the loss of more than 150 jobs. Brewing was transferred first to Cheltenham, Gloucestershire, and later to County Durham. But 'Kentish' ale that didn't come from Kent always seemed like a flawed idea, and the change of location brought to an end a chapter in Kent brewing.

Shepherd Neame are not the only people brewing in Faversham today. The Mad Cat Brewery was started in Brogdale, on the outskirts of Faversham towards the end of 2012. Based on a farm, with a distinct *Darling Buds of May* vibe about the operation, father-and-son team Peter and Mike Meaney produce three core cask ales – Platinum

Surviving Rigden's crest and, left,
the rear of the old brewery today.

Peter Meaney in action at the Mad Cat Brewery, Brogdale.

Raw ingredients at the Mad Cat Brewery, Brogdale.

Tonie Prins launched the Hopdaemon Brewery back in the year 2000.

Blonde Ale, Auburn Copper Ale and Golden India Pale Ale – alongside a diverse range of seasonal and bespoke beers.

Another Faversham duo brewing lovingly tended beer are Richard Bennett and Phil Dodd, who, under the name Boutillliers, are producing 'short run, hand-crafted, bottle-conditioned ales' from their base at Macknade, just off the Selling Road. Truly the day of the microbrewer is upon us.

Also in the Swale area, at Newnham, are Hopdaemon, one of Kent's longest established microbreweries, with a history that dates back to the year 2000 when it was set up by Tonie Prins, originally from New Zealand. With the emphasis on local ingredients, particularly local hop varieties such as Challenger, Goldings and Kentish Cascade, the brewery has grown steadily and carved out an enviable reputation in Kent, and further afield, for its excellent range of cask and bottled ales. These include the highly quaffable Golden Braid session ale with, at the other end of the spectrum, the formidable Leviathan, a 'strong, ruby ale'. My own favourite among the Hopdaemon portfolio is Incubus, a session bitter the colour of burnished copper. I would happily walk a long, dusty road in my bare feet if I knew there was a pint of this particular beer waiting for me at the end of it.

Incubus and Skrimshander
are two of Hopdaemon's
best-known ales.

King Cobb of Margate

The Isle of Thanet, which, as the name implies, was indeed a separate island until the Wantsum Channel silted up, has long enjoyed a reputation for the quality of its beer. Indeed, Samuel Pepys, in his famous diary, makes several mentions of 'Margette ale'. In an entry dated 7 May 1660, he writes about being sent '12 bottles of Margett [Margate] ale' by Captain Cuttance. 'Three of them I drank presently with some friends in the Coach'.

Any discussion about brewing in Thanet will always throw up two famous old companies, namely Cobb & Co. of Margate and Tomson & Wotton of Ramsgate.

Francis Cobb founded his eponymous brewery in 1760, initially based in King Street. The success of the venture would provide the foundations for a business empire that would flourish in such diverse areas of commerce as banking, shipping, salvage and even coal.

Indeed Cobb, who died in 1802, was such an influential figure in Margate that he was widely known as 'King' Cobb, a fact confirmed by a commemorative plaque that today adorns the wall of his former, once grand townhouse in King Street.

The brewery's success was founded on the quality of its ale, made from locally sourced barley and Kentish hops, although a contract to supply the Duke of Wellington's vast army of troops during the Napoleonic Wars did the business no harm at all. Cobb & Co. also benefited from Margate's growing popularity as one of the earliest seaside holiday resorts.

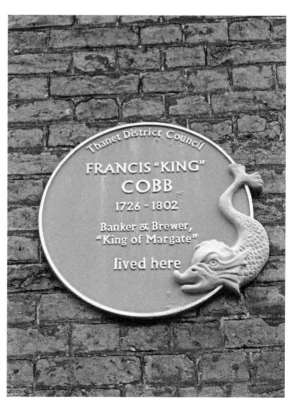

Plaque in King Street commemorating Francis 'King' Cobb.

Tomson & Wootoon's brewery in Queen Street, Ramsgate, shortly before demolition in 1968.

Cobb died in 1802 but, under the guidance of his son, also called Francis, the company continued to grow and, in 1808, a larger brewery was built on Fort Hill. This would be Cobb HQ for the rest of its history, from which a wide range of beers would be brewed and bottled down the years, including such delights at Cobb's Nut Brown Ale, Cobb's Crown Ale and the celebrated Margate Stout.

Cobb & Co. became a private company in 1947, but the merger and takeover madness of the post-war years was already apace. In 1968 they were bought by Whitbread and the brewery was promptly closed down. Despite their Georgian origins, the Fort Hill buildings were demolished in 1971 and the site is today occupied by the rather grim 1970s-built Margate police station.

In just a short stroll from Fort Hill, you will find the old George Hotel, now an Indian restaurant. A surviving window proudly proclaims, 'Cobb's Ales' and 'Cobb's Stout'.

Ramsgate's Thomson & Wotton were also, ultimately, victims of Whitbread's rampage through Kent and were also acquired by the London firm in 1968. Brewing and bottling at the Queen Street site ceased the same year, with the famous old Thomson & Wotton name and their noted ales both consigned to brewing history.

This seems a criminally sad state of affairs, given that Thomson & Wotton were reckoned to be the oldest surviving brewer in the country at the time, with a generally accepted founding date of 1634. However, some sources, somewhat hazily, suggest that the original deeds of the brewery can be traced back as far as the reign of Elizabeth I, possibly even a few years before she came to the throne.

Tomson and Wootoon livery, the Old Neptune, Whitstable.

Whitbread's acquisition of regional breweries was driven by the desire to acquire tied pubs in which to sell national brands such as Tankard, Trophy and a number of lagers brewed under licence. Thomson & Wotton had a sizeable pub estate throughout East Kent and a merger with Gardener's Brewery, Ash, in 1951 had added another forty-six pubs to their portfolio.

A Waitrose supermarket now covers most of the old Queen Street site, but some rare pieces of original Thomson & Wotton livery can still be seen in Broadstairs, Whitstable and, naturally, Ramsgate.

Thankfully, the brewing drought in Thanet is a thing of the past. Leading the pack, and brewing since 2002, is Gadd's, also known as the Ramsgate Brewery. Eddie Gadd served his brewing apprenticeship with the Firkin chain of brewpubs and started modestly out on his own, working with a tiny kit in cramped conditions in the rear of Ramsgate's Belgian Bar. Demand soon led to relocation to larger premises in 2006 and a big rise in production, which currently stands at around sixty barrels a week.

Gadd remains passionate about using Kent produce in many of his cask ales and the core range includes Gadd's No. 3, No. 5, No. 7 and Seasider; he has also brewed a green hop ale, using freshly harvested hops, and a 'Belgian style' golden ale – the latter perhaps a nod to the location in Ramsgate harbour from which his brewing empire began.

Gadd's are also renowned for brewing Dogbolter, a classic porter that was formerly a regular at David Bruce's chain of Firkin pubs. Dogbolter was the first beer Gadd ever brewed, back in his Firkin days, and remains a beer with which he is still closely associated. It's also the reason why my recollections of my eighteenth-birthday celebrations are hazy, to say the least.

Also brewing in Thanet, on a much smaller scale, are Isla Vale Alesmiths in Margate, albeit with a 'brew length' of only 'about two firkins', almost all of which is destined for some of Thanet's many micropubs.

Then there is Attwell's, in the village of St Nicholas at Wade. The Attwell name will be familiar to older residents of Thanet as coal merchants. For a time, they produced a handcrafted range of beers that included a Belgian blonde, a session bitter and a golden ale featuring US Chinook hops. At time of writing, however, plans were afoot for 'a new phase' in Attwell's history as they look to become a 'non-profit community-run brewery, which will offer opportunities and support to those that need it most'.

One of the more unique brewing enterprises in East Kent is the Four Candles in St. Peter's, Ramsgate, which is not just a brewpub but the smallest brewpub in Great Britain. Initially set up as a micropub by former journalist Mike Beaumont in 2012, the enterprising former news editor soon opened a two-and-a-half barrel brewery, which was somehow horned in at the tiny street corner site. There has been no looking back since, and the range of beer on offer changes regularly as Beaumont and company continue to experiment in the cosy confines of their brewery.

Two-and-a-half barrels is around 90 gallons, enough to fill ten firkins, and, in the words of the pub's website, to make sure they 'always have a Four Candles beer on offer'. The pub's name, incidentally, was inspired by a famous Two Ronnies sketch. Like the Foundry in Canterbury, the Four Candles has revived the ancient practice of innkeepers brewing their own ale, 'out back' as it were. It's very good ale, too.

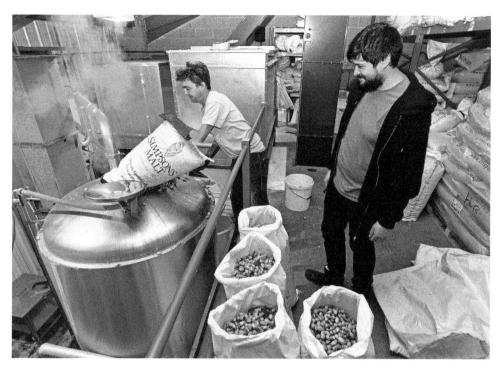

Eddie Gadd adds hops to the copper at the Ramsgate Brewery.

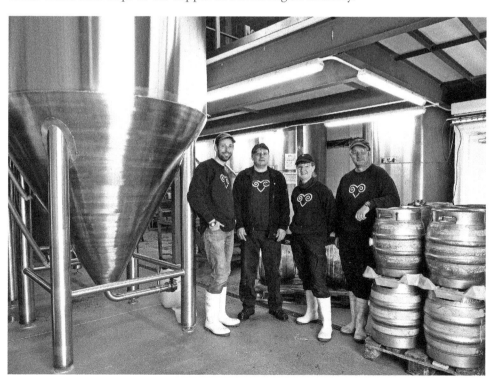

The production team at Gadd's, the Ramsgate Brewery.

Gadd's ales can be found throughout East Kent and beyond.

Right: Rye Pale Ale is casked at Gadd's in Ramsgate.

Below: Mike Beaumont in action at the Four Candles. (Brian Green)

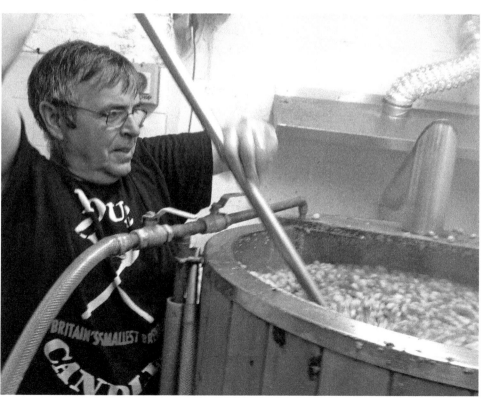

Mike Beaumont and Paul Wenham-Jones at the Four Candles. (Brian Green)

West Kent

History and anecdote tell us that Winston Churchill liked to drink, and he is most associated with wine and spirits, in particular brandy. So it is fascinating to discover that unearthed in the Churchill Archives were receipts for beer bought from the old Black Eagle Brewery, which for many years operated in Westerham, just 2 miles from Chartwell, Churchill's country home from 1922 until his death in 1965. Perhaps the great man liked to occasionally relax with a glass or two of pale ale as he digested world affairs?

The Black Eagle Brewery, Westerham, now sadly demolished.

Well-heeled Westerham is both the location of one of Kent's most-famous lost breweries and also one of the county's most-respected modern-day beer producers. There are records of brewing in Westerham dating back to the early sixteenth century, but the town was really put on the beer map in 1841 when Robert Day launched the Black Eagle Brewery at the western end of the high street. Initially their forte was pale ales.

Expansion and closure

In 1862, Day was joined in partnership by Ben Bushell and, under his guidance, the brewery went from strength to strength, its beer reaching a far wider marketplace than its West Kent heartland, eventually morphing into the company Bushell, Watkins & Smith. In 1881 a branch line was opened connecting Westerham with Sevenoaks, allowing the company to transport their beer directly to London. As the nineteenth century came to an end, the Black Eagle Brewery was by some stretch the biggest employer in Westerham.

Despite the fine reputation enjoyed by its many beers – Westerham Ales were drunk by British troops in Normandy following the D-Day landings and by RAF airmen at nearby Biggin Hill – the company was not immune from the slings and arrows of the post-war merger and takeover mania. In 1948, it was acquired, alongside 125 of its pubs, by London brewer Taylor Walker, in turn becoming part of the Taylor Walker/Ind Coope 'big six' conglomerate in 1959.

On 25 September 1964, the headline on the front page of the Westerham edition of the *Sevenoaks Chronicle* proclaimed 'Shock for beer drinkers'. It also informed its readers that 'Westerham bitter goes off next March' and 'Brewery to cease production'. And so, on 3 March 1965, the last-ever brew at the Black Eagle Brewery took place when head brewer Bill Wickett oversaw a limited run of Special Bitter Ale. It would mark the end of almost 300 years of continuous brewing on the same site.

It is worth raising a jar or two to Wickett, a man who clearly loved the Black Eagle Brewery and its legacy. He had the foresight back in 1959, when the writing was probably already on the wall for the Black Eagle, to deposit some of the brewery's original strains of yeast at the National Collection of Yeast Cultures (NCYC) in Norwich, where it was safely stored in dormant form as a freeze-dried sample.

Brewing returns to Westerham

The NCYC is 'the UK's premier collection of yeast cultures' and, when they were contacted many years later by a brewer called Robert Wicks, two of these Black Eagle Brewery yeasts were re-cultured – by Dr Keith Thomas at the University of Sunderland – to be used by the newly formed Westerham Brewery, which was set up by the aforementioned Wicks in 2004. The yeast was acquired from Carlsberg UK, who, as is often the way in the merry-go-round that is the British brewing industry, had somehow found this precious commodity in their ownership.

The Westerham Brewery have not looked back since. Based in Edenbridge, they produce a mighty fine range of ales, including the likes of Grasshopper, a dark bitter featuring Target hops from the National Trust's Scotney Castle hop farm; the mighty Audit Ale, based on a popular bottled beer produced by the old Black Eagle Brewery;

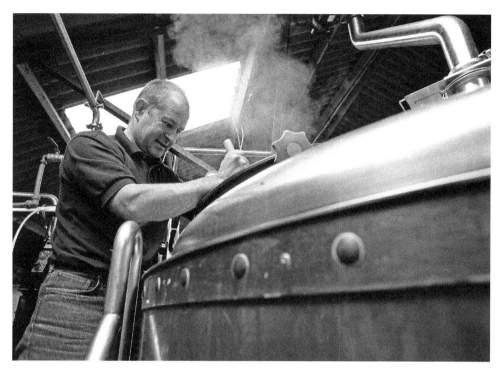

Robert Wicks has revived brewing in
Westerham.

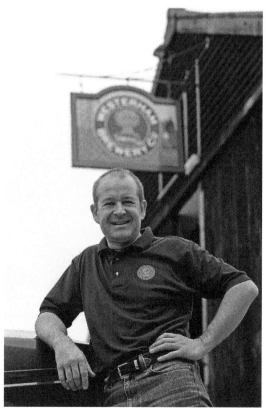

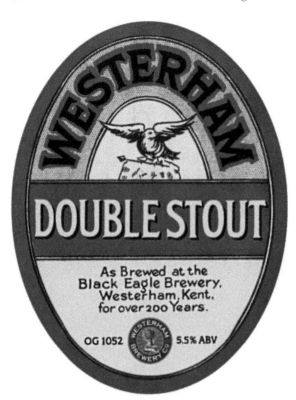

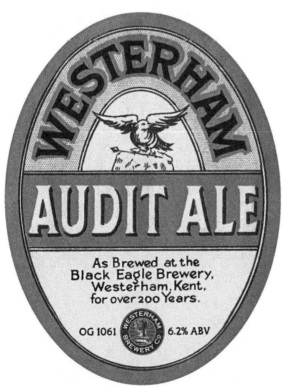

Many modern Westerham
Brewery labels pay
homage to old designs.

The sign of the Westerham Brewery.

and a Double Stout brewed for the winter months and, once again, based on an old Black Eagle Brewery recipe. This nod to the past is reflected in the retro design of many Westerham Brewery pump clips and bottle labels.

Back in March 2015, to mark the fortieth anniversary of Bill Wickett's famous last Black Eagle brew, Wicks and his team brewed a special batch of Westerham Special Bitter Ale. They followed a very similar recipe to that used by Wickett and also used water sourced from the same greensand aquifer. The Westerham Brewery story is one of renaissance and revival, truly the stuff to lift the spirits of anyone who cares about local history and tradition in the face of bland corporate hegemony.

The old Black Eagle Brewery, an impressive and elegant collection of buildings, has sadly been demolished. However, the General Wolfe pub, a Grade II listed sixteenth-century hostelry located on the north side of Westerham High Street, is still with us. This was the former brewery tap house.

Larkins

Another West Kent brewing story that lifts the spirits, and reinforces the growing belief that small is often beautiful, is that of Larkins Brewery near Chiddingstone. In 1986 Bob Dockerty bought a selection of brewing equipment from the struggling Royal Tunbridge Wells Brewery, based at Rusthall. Dockerty, a famer, already knew a thing or

two about brewing and beer. In addition to growing hops, he also had some experience of producing his own ale at home.

Brewing under the Larkins name, Dockerty at first operated out of the Royal Tunbridge Wells Brewery's Grange Road site but soon moved operations to his own farm, setting up shop in a former cowshed. It has been at its current location since 1988 and the whole operation is almost as H. E. Bates as it at first sounds. It is one of the more charming brewing stories you are likely to encounter.

Over the years Larkins have earned a fabulous reputation for their core range of three traditional ales alongside two seasonal offerings, one of which includes the fabled and much-sought-after Larkin's Porter. The brewery's beers are supplied to a select number of outlets, and it is not unknown for beer connoisseurs to travel many miles into the Kent heartland to sample their ales.

The set-up down on the farm is a small one and the team includes Dockerty, both owner and managing director, working alongside his nephew Harry Dockerty, who remains in charge of brewing. The Larkins logo features both a traditional Kentish oast house and a hop. Combined, these two images are strangely reassuring.

West Malling and Tonbridge

The Kent Brewery in West Malling was established in 2010, following a chance meeting between Toby Simmonds and Paul Herbert in, of all places, a pub. It was clearly a Stanley-meets-Livingstone kind of moment, for both men had a clear passion for beer. Together their aim was, in their words, to 'help take Kent in a new direction ... one that is based upon Kent's oldest tradition – innovation'.

Toby Simmonds and Paul Herbert are the men behind the Kent Brewery.

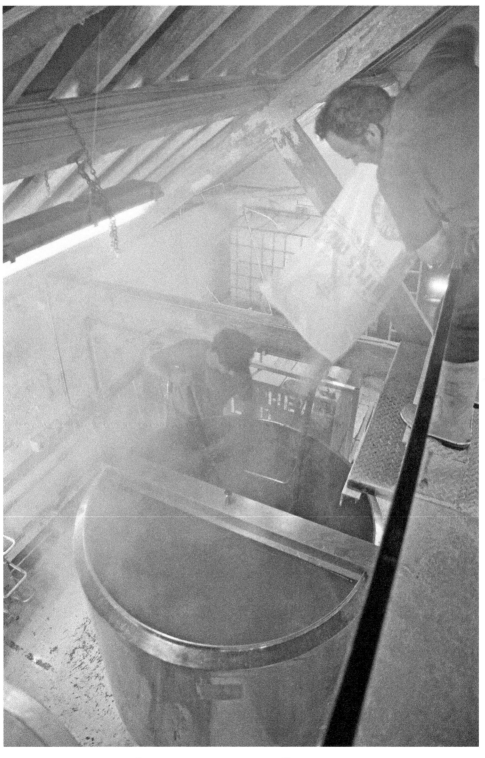

Brewing commences at the Kent Brewery, West Malling.

Fresh beer is casked at the Kent Brewery.

The Kent Brewery.

The Kent Brewery source many of their ingredients locally, including some hops.

The end result of this chance meeting is a West Kent microbrewery that produces around fifteen different beers, including the in-house beer for the Craft Beer Co. chain, which, in addition to several hugely popular London pubs, now has a branch in Brighton.

They also brew a Saison, a traditional Belgium farmhouse style of beer, alongside American-inspired pale and brown ale, and a classic light English pale ale.

Herbert and Simmonds have also established the Primal Sour Beer Works, the aim of which is to produce sour, barrel-aged beers.

Also started in 2010, originally in Tonbridge but now based near East Peckham, was the Tonbridge Brewery. Originally working with a four-barrel plant, the demand for their beer hastened relocation and an expansion to a twelve-barrel set-up.

They produce a core range of seven beers, which predominantly use locally grown Kent hops; however, four American hop varieties feature in their Union Pale, which

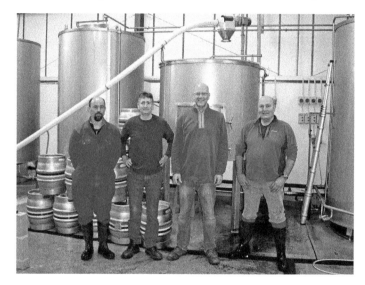

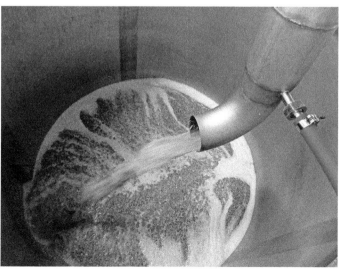

The brewing team at the Tonbridge Brewery get ready to 'mash in'.

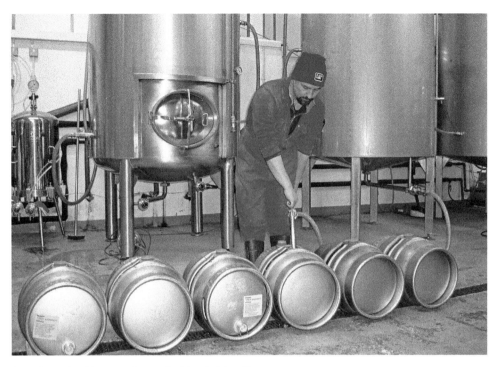

Beer is racked into casks at the Tonbridge Brewery.

Casks of beer, ready to leave the Tonbridge Brewery.

The brewery's Rustic Ale was voted 'best hopped ale in Kent' in 2015.

was a regional gold Society of Small Brewers Association winner. The live strain of yeast used by the Tonbridge Brewery originated from the famous old London company Barclay Perkins, later Courage. This is pure history in a glass methinks, as the history of Barclay Perkins can be traced back to the early fifteenth century, when they started brewing in Southwark, south London. For much of the eighteenth century, it was owned by the Thrale family, who famously took to the lexicographer Dr Samuel Johnson; upon Henry Thrale's death in 1781, Johnson was one of executors of his estate.

In what has become one of the most famous beer-related quotes, Johnson said at the time: 'We are not here to sell a parcel of boilers and vats, but the potentiality of growing rich beyond the dreams of avarice'. All of which is food for (historical) thought the next time you treat yourself to a pint of Tonbridge Coppernob.

A beer for Bob

On New Year's Eve, 2012, Sean Ayling and Robin Wright produced their first batch of beer together, a ruby rye beer made with American hops. From these humble beginnings Pig & Porter were formed and, just three years on, the same Red Spider Rye was named best beer in Kent by the RateBeer website. No mean feat for two men who met for the first time while playing for the same village cricket team.

Pig & Porter initially operated as a specialised event-catering business, aiming to combine Ayling's brewing experience with Wright's food knowledge. Since then, however, the emphasis has shifted mainly towards brewing. Initially, they led something

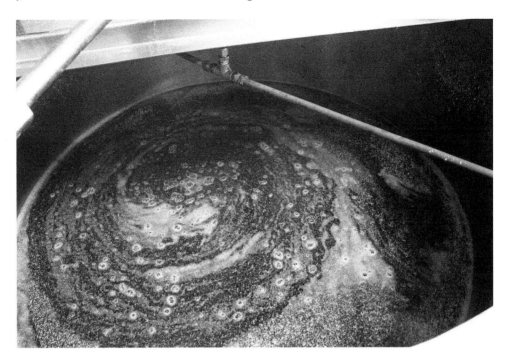

Another mash gets underway at the Pig and Porter Brewery. (George Fisher)

of a nomadic existence. As Wright told the *Brewers Journal* in 2015, 'We brewed our first beer on New Year's Eve 2012 and thereafter brewed as often as we could at several microbreweries in Sussex and Kent'.

Today the brewery has its own base on an industrial estate in High Brooms, just outside Royal Tunbridge Wells, from where they produce a core range of six beers – cask, keg and bottle – alongside a number of seasonal and one-off brews. The site was formerly occupied by the former Royal Tunbridge Wells Brewery.

One of the highlights in Pig & Porter's relatively short history was brewing a special bespoke beer for BBC DJ and *Old Grey Whistle Test* icon Bob Harris, Whispering Bob IPA. Meanwhile, as big cricket fans, Ayling and Wright were delighted when they were asked to brew a beer for Kent cricketer Darren Stevens's benefit year in 2016.

A game of cricket would not be out of place at the Swan on the Green in West Peckham, which, as the name suggests, looks out onto the village green. It's all very *Midsomer Murders,* although without the murders obviously. The pub itself can trace it roots back to 1526 and, in the year 2000, a microbrewery was set up, the brainchild of landlord Gordon Milligan, who had acquired the pub the year before. It would once have been very much the norm for inns and taverns to brew their own beer on the premises and, as such, the Swan on the Green has revived an age-old tradition.

The brewery are rightly proud of using, for the most part, natural and locally sourced ingredients, and have a core range of eight craft cask ales, primarily to be served at the adjoining pub. This is surely as 'local' as local beer can ever be. I'll drink to that.

Pig & Porter.

Acknowledgements

Rolling barrels down 'the Street' at Shepherd Neame, just before the Second World War. (Shepherd Neame)

No man is an island, and I am grateful to a number of people who have helped in one way or another with putting this book together. For supplying information and/or photographs, I want to say thank you to, in no particular order, Sue Fisher and Eddie Gadd at the Ramsgate Brewery. Also to John Humphries and co. at Shepherd Neame, who allowed me access to a wealth of amazing photographs and images. I'd also like to thank Tonie Prins at Hopdaemon, Matt at the Romney Marsh Brewery, Darren Millis at Dartford Wobbler, Michael Beaumont at the Four Candles (got any peas?), Martyn Hillier at the Butcher's Arms, the good people at the Kent Brewery, at the Wantsum Brewery, at Mad Cat, Larkins, Maidstone Brewing Company, Caveman, Howard Goacher at Goacher's and the Musket Brewery. And not forgetting Michelle at Rockin Robin, Virginia at the Old Dairy, Liz at Westerham and Sam at Time and Tide. Also, hats off to the fine, upstanding people at the Labologists Society (www.labology.org.uk), who allowed me to use some images from their extensive and magnificent collection, and Bryan Williams at Dover Museum.

Bibliography

Old brewers' books
from the Shepherd
Neame archive.
(Shepherd Neame)

Cornell, Martyn, *Amber, Gold and Black* (Stroud, The History Press, 2010).

Sarto, Darcy, *Lady Don't Fall Backwards* (Otley, Skerratt Media, 2014).

Filmer, Richard, *Hops and Hop Picking* (Risborough, Shire Publications, 1982).

Glover, Brian, *Camra Dictionary of Beer* (London, Longman Press, 1985).

Haydon, Peter, *Beer and Britannia* (Stroud, Sutton Publishing, 2001).

Jackson, Michael, *Great Beer Guide* (London, Dorling Kindersley, 2000).

Lawrence, Margaret, *The Encircling Hop* (Sittingbourne, SAWD Publications, 1990).

O'Neill, Gilda, *Lost Voices* (London, Arrow Books, 2006).

Percival MBE, Arthur, *A Short History of Rigden's* (Faversham, Faversham Society, 1998).

Protz, Roger (Editor), *Camra's Good Beer Guide 2016* (St Albans, Camra Books, 2015/16).

Yarde, Doris M., *An Anthology of Porter* (Faversham, Faversham Society, 1998).